HENSCHE ON PAINTING

John W. Robichaux

Introduction by
Dorothy Billiu-Hensche

DOVER PUBLICATIONS, INC.
Mineola, New York

Copyright

Bibliographical Note

This Dover edition, first published in 2005, is an unabridged republication of *Hensche on Painting: A Student's Notebook,* published by John W. Robichaux, Thibodaux, Louisiana, 1997.

International Standard Book Number: 0-486-43728-0

Manufactured in the United States of America
Dover Publications, Inc., 31 East 2nd Street, Mineola, N.Y. 11501

DEDICATED IN MEMORY OF
HENRY HENSCHE
1901–1992

Cor ad cor loquitur.

Acknowledgments

My special gratitude to Dorothy Billiu-Hensche,
for her devoted care of Henry Hensche's work
and life, and for introducing me to Henry.

§§§

My loving gratitude to my wife,
Sandra C. Robichaux, and my two sons,
James and Andrew, for living with a man
obsessed with painting.

§§§

My forever gratitude to my parents,
Abe J. Robichaux (deceased)
and Muriel G. Robichaux,
for sending their small son to
France Folse
in Raceland, Louisiana,
for his first art lessons.

Contents

Introduction

"You do not paint what you see, you paint what you have been taught to see."

Henry Hensche, an outstanding painter of a large volume of work, always shared this advice with his students. Throughout his life, unlike so many of the great painters of the past, Henry devoted much of his time sharing his knowledge, his time, and his painting ability. Despite this, he has remained a sort of hidden treasure.

This book is intended to reveal the basic painting philosophy and methodology of Henry Hensche. Those readers who study each page in the text should develop a broader and truer perspective regarding their own visual perception of nature.

I met John about twenty-five years ago. He was a bright young man who has become one of our area's best high school history teachers; the teacher who sponsors cultural events for active high school students. He has become a community leader, serving on many boards, spending summers with his family and painting in the Southwest. His wife Sandra teaches music and is the choir director for their local church. Even with two sons, one in college and one in high school, both are very active in the cultural life of their community and interested in arts education.

It is John's interest in painters needing to understand the importance of Henry Hensche's teachings that led to the creation of this work. The information presented in the book was obtained through years of personal conversations and documented by taped interviews with Henry Hensche here in Gray, Louisiana, and in Provincetown, Massachusetts.

1

Many times I heard Henry say, *"What comes from the heart, goes to the heart."* John Robichaux heard it, also. This book speaks from the heart.

Gray, Louisiana DOROTHY BILLIU-HENSCHE

The Hensche Legacy

Living in tenuous circumstances at the beginning of a career was the norm for generations of successful painters. One cannot help notice how Henry Hensche's teacher, Charles Webster Hawthorne, lived in a fishing gear shack at William Merritt Chase's Shinnecock studio, and then Henry Hensche had to live and paint without heat in his early days at Cape Cod. It is the quintessential badge of accomplishment for all but a few who make the arts a successful career to suffer discomfort and rejection in their early careers. This comparison is but one of many between the old master and the young master. Neither man came from a distinguished art background, but both men invested their youths in pursuit of the aesthetic. Both struggled to learn the classical traditions taught to all students earnestly seeking success in their times, but two inevitable differences will forever mark Hensche as the *avant garde* of the two. First, Hensche refined the teaching process for seeing color. Then, in his own paintings, he achieved the light key in all settings as had never been done by any other painter in history.

While Hawthorne's great commercial success did allow him the luxury of inquiry into making impressionism a teachable movement, it was Henry Hensche who made the teaching practical. The bulk of Hawthorne's work in print or in public view demonstrates Hawthorne's repeated mastery of painting the head with the finest gradations of color—the antithesis of Sargent's bravura brushwork. The notes collected and published in 1938 by Mrs. Hawthorne, called *Hawthorne on Painting*, demonstrate Hawthorne's understanding of a visual knowledge of color not readily evidenced in his formal portraits.

He was obviously teaching his students color painting in the best way he knew for the time. Hawthorne was attempting to teach his students how to see and paint the new vision of the turn of the century. At the same time he apparently wrestled with a teachable method other than his own anecdotal knowledge overlaid on the rigors of a dated academic style. His innovation of having the students paint with putty knives was the beginning of a discipline to be perfected by his own studio assistant. It was Hensche, in Hawthorne's final years, who arrived at a solution to allow students to grow in their knowledge and use of color with this new vision.

Henry Hensche acknowledged that painting block studies in different lighting conditions was not his original idea but that of a friend from Philadelphia. Along with the putty knives, Hensche's bricks, boxes, and blocks became the painter's fodder of still life in the sunlight. They were the poor man's *Grain Stacks* series that would give the novice or the advanced painter the opportunity to see how each plane change is a distinctive color change even though the local color of the object is identical on all sides of each block and was previously painted as tonal differences. The student could easily study the color differences between a gray day and a sunny day and advance to as many nuances as he or she could see.

Hensche never failed to express how important doing these studies was to the development of a color realism not attainable by any other method of study. Even in his artistic maturity he painted blocks. If students asked when they would ever stop painting blocks, his answer would be a quick "Never!" Just as great musicians warm up with scales and studies, the virtuoso painter should never stop his or her studies. This was the motivation for Hensche. For all paintings are studies. The rush to paint the subject would have to be tempered until the student understood that beauty in painting rested in the richness of the painter's vision and not in the lavish objects before him.

It is for this reason that Hensche always viewed paintings as analytical reductions of the block studies. Light key, masses, and variations in the masses were the essentials of all visual logic. No painting pretending to realism in his time could escape the

triad. Hensche was not artistically entertained by modernism in the forms of Dadaism, Minimalism, Symbolism, Surrealism, or any "isms." His analyses did not regard the subject or narrative that is so often the core of a museum docent's spiel. He never denied the contributions of historically noted painters through the ages, but was quick to skewer a confused vision that lacked a sense of visual logic.

For Hensche, what could be learned from the masters was the historical context of painting in the modern. "If you could give me the ability to paint like Rembrandt I would reject it." Undoubtedly, Hensche repeated a warning to those who thought their training should include painting as the masters had painted: "It's been done." Why would a painter in our time want to be a Renaissance painter, a Baroque painter, or a French Impressionist? Can we make a Raphael better than Raphael? Hensche thought not. Improving on the past certainly meant understanding it, but not recreating it. For Hensche, the continuum of Western thought meant taking painting to new frontiers. This he did in two very distinctive ways. As a teacher and as a painter he transformed the painting genre to make modern art something more than an "ism."

Hensche—The Teacher

With no degree from a prestigious university and only the experience of having worked under studio tutelage, Henry Hensche became a studio assistant to Hawthorne and was simultaneously forced to learn painting and teaching. Hensche continued the teachings of Hawthorne after his master's death, changing only the name of the school from Hawthorne's "Cape Cod School of Art" to Hensche's "Cape School of Art." He became his own director and solutions to the visual problems were no easier for him, even as the new master on the Cape. In our conversations he constantly said, "solving the problem of . . ." Teaching honed Hensche's problem-solving skills while giving him the attitude necessary for becoming a great master painter.

To convey the teachings of Hawthorne in a way a beginner

would understand them, Hensche had to modify and convey those teachings, not as he understood them, but as others would need to understand them. The solution to this problem led to "block studies" done in all light keys, and a progressive analysis process of developing masses of light and shadow, each having distinctive divisions and subdivisions. This was a process of analysis of one's own ability to see, not a "how-to" craft approach. In a way, this could be Henry Hensche's most profound legacy.

The approach allows anyone to spend a lifetime in growth of the skills in painting and seeing not found in the common art academies, colleges, and studios. Most of their approaches to painting lean more to the craft of painting. In numerous art magazine articles and "how to" books, anyone can read the accounts of how to make pictures and virtually nothing about visual development by the analysis of light key and color. The articles are successions of how artists make paintings and with the emphasis mostly on materials. This is understandable since magazines are also filled with advertisements of art suppliers. However, there are exceptions. Henry's own article in the April 1977 *American Artist,* expertly and perceptively written by Charles Movalli, says nothing about brush size or type of canvas. Its depth stands in great contrast to what is written about other painters.

Good art instruction for Hensche was aiding the student to develop the logic of seeing and the painting process, simultaneously. This logic was not evident in institutional instruction. Hensche often attacked the way most colleges educated their students in studio painting. He believed the colleges of art allowed students to follow paths of free expression with little discipline. Their free expression painting culminated in a *tour de force* senior exhibit which made little sense to Henry. He thought these students did learn to paint in topical series, but they misunderstood the visual logic of Monet's own *tour de force* series—the *Grain Stacks.* For Hensche, college students painted their series for thematic reasons and Monet painted his series for visual growth. Visual growth was Hensche's own *raison d'être.*

Hensche—The Painter

If Henry Hensche had become an academic painter in the mode of the National Academy, or one of the "ism" painters of the last half of this century, I doubt if I, or many others, would have paid him much attention. His core devoted followers of today are those who found academy and "ism" painting either spent or pretentiously unintelligible. Neither did they hold any attraction for Hensche.

The affective immediacy of Impressionist works gave rise to their broad popularity over the last century. The ubiquity of Monet reproductions and blockbuster sellouts of his museum shows are proof of the timelessness of his works. What is it about Monet's works that attract us? Hensche understood how for Monet the subject was the light, and he stated many times that the only way anyone can see anything is by the light key of nature. He understood that the general public had little formal artistic knowledge, but almost anyone could recognize without a watch if it is morning or afternoon by simply looking out of the window. This is what makes Monet easy to relate to for even the artistic unwashed. Monet's works are affective without pretense to glorification of an object, a narrative, or a social issue.

Innovators in painting are truly rare. Those generally considered the *avant garde* of 20th-century painting are given honor for a "vision" having nothing to do with vision itself. Finally, in Hensche, we have a painter who sees and paints beyond Monet himself. For those who think Monet exhausted the visual in painting, Hensche pushes the edge of vision to a color and atmospheric level only hinted at by Monet. The two can hardly be compared because Hensche did his own kind of *Grain Stacks* series and ventured to a new level of seeing. Is it possible for someone to reach a level of visual perception that the celebrated Monet himself never attained? How could this be?

Monet proved how the *envelope* of the atmosphere changed with the passage of the sun and the seasons. What Monet never clearly demonstrated was how the *envelope* was different even in different north light keys. Monet's only portrait that even

hints at an interior light key is his touching quick sketch of
Camille in death. Even his own remorseful commentary gives us
the idea he was observing the color of death and not the light
key of the room where the painting was done. This is not so with
Hensche.

Hensche demonstrated the differences by simultaneously
painting at least two formal still life paintings in his north light
studio with one being done when the sky was clear and the other
in the north light on a gray day. While other painters have made
this attempt, only Hensche's sensitive studies reveal the distinc-
tion. Placing these paintings side by side reveals more than just
subtle differences, but distinctions of light key can be recog-
nized. Only a person with Hensche's eye and ability could reveal
this effectively.

Even beyond this, Hensche achieved an aerial perspective in
the narrow depth of a still life painting. While others achieved
depth by gradations of tonality or focus, Hensche infused his
still life paintings with the same *envelope* of atmosphere Monet
could paint in his finest landscapes. A comparison of Monet and
Hensche still life paintings immediately convinces the viewer
that Hensche achieved a greater variety in the qualities of light
that the Monets clearly lack. In fairness to Monet, it should be
noted that he virtually abandoned still life painting by the
1880's, and he had yet to make his discoveries in the *Grain
Stacks* series.

Hensche took the north light still life to a degree never
achieved before by truly living with them during the winter in
his studio on Pearl Street. With the benefit of time and lonely
concentration, his honed vision solved the problem of achieving
this atmosphere in the shallowest of depths. I contend his vision
went even beyond this by creating in the same lateral plane an
aerial quality between objects. This subtlety can only be seen by
a sequential viewing of Hensche's still life paintings from the
early 1970's through the 1980's.

Most of these paintings were sold almost exclusively to clients
in Louisiana. The heavy concentration of those later works in
one place has afforded this observer, and others, the opportunity
to compare the unbroken sequential progress of Hensche's

painting. It allowed Hensche to see his own works repeatedly as he could "visit" them again and again. Undoubtedly, Hensche was able to play a game of one-upsmanship with himself. He knew he had ventured into a frontier of seeing and painting that he alone could appreciate fully. But like all great painters, he wanted even more.

The whole of a painter's life can be found in his last paintings. They should represent the summation of all the painter has learned. But the final picture is never a completed work. It inevitably asks more questions than it should ever answer. What great artist ever felt all had been said or done? Henry Hensche's study of history and painting dictated to him a command to build on the evolution of painting and seeing. Hensche commissions us to follow the same command. This is his legacy.

Foreword

Ever since meeting Henry Hensche in the early 1970's, my life and painting have been transformed. Like others who lay claim to this transformation, I knew I stood diminutive in the shadow of painting greatness.

Hensche was no ordinary painter. He possessed the standard unusual characteristics commonly associated with "artists." But anyone could recognize his sincerity for pure painting and not for himself. It was what he taught that really mattered to him and who taught it to him. The name "Hawthorne" was ever on his lips as he gave Hawthorne all the credit. As a matter of fact, he often said he would be content to spend all of eternity cleaning Hawthorne's brushes. Those who have seen the bodies of work left by both men know that this student, Hensche, had eclipsed the master. I had studied the words of his beloved Hawthorne and now Hensche's words are even more important to me.

Henry often spoke in a stream-of-consciousness mode peppered with parenthetical points. He was ever "parallel thinking" to clarify his own understanding. This made him difficult to follow, because he was never holding a conversation with you but the dialogue seemed to be with himself. Always he repeated his dogma and occasionally asked you for validation of his point. As though he needed your approval. When he would do this I would claim that Henry was "holding court." He held all the evidence and prosecuted his case while he judged it. And like a good prosecutor, he hammered his point by repeating litanies of conclusions to insure the jury would not forget them in deliberation. Henry did this with important to remember phrases, ". . . the light key of nature," ". . . hold to the masses," ". . . visual perception." Those who knew Hensche knew these pet lines. If Henry

sounded repetitive it was because he was repetitive. These were no dawdling geriatric repetitions without purpose. By jackhammering his ideas he hoped the mantra was preserved.

On the other hand, Hensche never spoke of painting without speaking of all its historical antecedents. He firmly believed that you could never be a good painter without being an equally good student of history. Dear to Henry was the belief in the simple goal of Western civilization to always rise above its previous generation through the progressive development of ideas. This he proved in his ideas about color and light. He proved it conclusively in his paintings, which go far beyond Monet's original development of color notes.

Hensche, at times, was an iconoclast; a term he reserved for Monet. At other times he seemed to be out of cadence with his fellow Provincetowners, like Hans Hoffman, Ambrose Webster, Max Bohm, and many others. Some times he was the David against the Goliaths of academia. Was he old-fashioned by holding on to a vision spent by the Impressionists? What was he trying to say with all of this beautiful color?

At first I did not know the answers. This small book is the result of my innocent early lack of understanding of what Hensche was trying to say. My background as an educator mandated the taking of copious notes. Notes for remembrance are important to me, but more important for later digestion. I knew I would not understand everything he was saying in the beginning, but with further learning I knew I could understand.

This book is the result of those notes and hours of taping. Henry and I would sit in Studio One, in Gray, Louisiana, and more often than not, all I had to ask was one question and an hour of tape would be filled. Transcribing these tapes to print proved to be a nightmarish task because of Henry's ability to skip along the surface and then plunge deep into one point, only to emerge back to an original point he was trying to make.

The transcriptions were meant to be my own personal reference text. They continue to serve me as well as I knew they would. I have decided to share my notebook with others who may find enlightenment from our master's words. Though Hensche died on December 10, 1992, he continues to teach us.

He does this through his paintings. But I realized the paintings are not available to everyone and so his recorded words could serve to help others. He did this first through his original manuscript of *The Art of Seeing and Painting*. Every painting student should read this work first and foremost above anything *any* student of Hensche ever produces for print.

For those students reading the words of Henry Hensche for the first time I'll give you fair warning. You will not understand everything. These understandings will come as you work along his path. His same words will have different meanings for different levels of students.

You will rejoice when you come into a knowing. But you will not come to this knowing without the discipline Henry demanded from his students to develop his single valued idea of painting in the light key of nature.

I soon learned that anyone who stood in his way or didn't devote himself to the same ideal was *persona non grata* in Henry's eyes. Years later, while studying with Henry in Provincetown, I saw his disdain for those who treated the arts as a hobby. Once, while he was standing in the bright Cape Cod light critiquing students' works, an elderly female student started showing another student her work. It obviously had the influence of another painting instructor from upstate New York. Henry grabbed my arm and in a voice loud enough for the lady to hear said, "Pay no attention to her. She flits like a butterfly from bush to bush." His point was very simple. She had learned a little from several instructors and incorporated these small bits of learning in her works. Not that this is totally bad. Henry's problem with her meandering was that she had not fully absorbed any discipline.

Hensche believed dedication to the development of an idea or an ideal was success in itself. Diligence was its own reward and success was paid off in knowing what the next challenge would be.

May this book lift you to the challenge of ever higher visual perception.

Thibodaux, Louisiana JOHN W. ROBICHAUX
November, 1997

§§§

Contrary to general belief,
an artist is never ahead of his time,
but most people are far behind theirs.
—*Composer Edgard Varèse*

§§§

The Notes

In the following sections my writings are in *italics*. All the rest of the text was derived from my own handwritten notes, taken while studying with Hensche, and from transcriptions of tape recorded conversations conducted over several years. The majority of these recordings took place in the fall of 1988.

Making Sense

"Because it makes sense!" How many times did his students hear this expression? We would ignore it, as we do with any other cliché, had it not been for Hensche's ability to demonstrate through hard work the sense and order he so dearly loved. He believed in the sense he had learned and he wanted to teach it.

Hensche believed in the learner, too. Maurice Grosser, in his book The Painter's Eye, *summed it up by writing, "Real painting is not done on talent. Real painting is the expression of visual ideas. Talent is only the grease that helps the wheel go round. But if the painter has somewhere to go, he can creak along perfectly well without it." Henry wanted to teach real painters to make sense.*

The following words of Hensche are the "make sense" conclusions he resurrected time and again to drive home his points.

§§§

You want the *language* to be taught when you go to a contemporary "art" school. (The term is wrong. They should be called painting, drawing, and design schools, as the definition of art is something else.) What you do with the language in the selection of color shapes to express an idea comes from human experience. As Robert Frost, the poet, told me, "You can teach language, but what you say with it and how you say it cannot be taught." He also said, "Poetry is philosophy in verse."

§§§

15

The student of painting has to learn to express in color whatever comes to the retina as he distinguishes those objects by their color. Color relationships must be studied, then the proportions of the color, and then you study drawing.

§§§

Because of the way academia has treated the Impressionists in the apparent continued teaching of the tonal school of painting, they have relegated the findings of Monet as part of a dated art experimentation in history. They are, of course, wrong. We can go further than Monet.

We are now at the stage to have a painting system to fit all the nations of the world. Some societies were arrested in their development and others advanced. Some artists carried their progress over the limitations of their society as the societies collapsed back on themselves. If a society doesn't need a tool, it then disappears. It must be fed with science and knowledge to thrive. The Greeks are an example of this in the art of sculpture. They nurtured it because of the need of their society for the pagan images. Their gods were wonderfully developed with human attributes, like Zeus and Athena. Their gods were not philosophical beings, but they had human qualities. Because their gods had these human qualities, their sculptors were expected to give them glorious human forms.

Our societies have developed to the highest levels where we have the means to produce commodities of good and evil. The arts themselves have dealt with understanding these physical and realistic phenomena. Painting is the growth of this understanding. We have enough pigments today to create realistic illusions to match finer perceptions. Our eyes can't see the developments of our science. The attempt should be to make a language in art to understand each other, like Esperanto for the spoken language.

§§§

When doing studies, sense tells you that you are at the end of

your ability. You must put the colors that express the essential truth. Indicate the light key and the aerial perspective. The time to make this advanced statement will not take much longer than the first cruder ones you struggled to make in the beginning. This makes you realize that it is not the time you spend on basic laying in of the essential masses, but rather the many studies you have made previously which increase your color sensitivity and ability. Perhaps you've tried to work a long time on a painting and think the longer you work on it the finer it will become. If you work too far beyond your ability on a study, you will make the color notes worse. Start a new study.

§§§

Aerial perspective was achieved by all painters prior to the Impressionist movement by varying the *tone* quality of a note to the lighter shade. The Impressionists, chiefly Monet, achieved aerial perspective by varying the *color* quality of a note.

§§§

The failure of cubism is the attempt of the painter to defy the physics of dimensions. Any attempt to demonstrate a third dimension by showing all sides of an object on a two-dimensional surface is as senseless as trying to sculpt in two dimensions. Even Picasso abandoned the effort.

§§§

Chemists, in about 1840, invented fine new colors for painters. If you call yourself a realistic painter and you don't use the finest and purest colors, then you are not a realistic painter since you are inventing color schemes of your own.

§§§

Some house painters are better painters than some "modern" artists.

§§§

People are losing their sense of inquiry. They aren't asking enough questions in the arts. They are accepting what they see. Challenge something even if you are wrong. Don't even believe me without question. Accept my visual truth only after you've questioned it and it makes sense to you. If you believe me without inquiry, then you are fooling yourself.

I've had to show people that much of what was produced in the 20th century was accepted without comprehension.

§§§

Art deals with the sensory development of man on a higher plane. An animal's sensory development is for survival. Man's is for self-development. It is really what separates us from the animals.

§§§

No great idea can develop at the speed of the many splintered movements of the 20th century. It took Darwin many years to develop the ideas in his *Origin of Species*. Physicists worked slowly to get to the scientific achievements of today. It only appears that things are happening rapidly. Einstein worked for many years on his theories. Truly great ideas take time to develop. So it is with painting. It takes years of study. Frivolous ideas, like most of those in the 20th century art world, are cheap and common. Truly new ideas of great worth are hard to obtain.

Hensche on the Landscape

When man first painted recognizable forms, the landscape form was simply the background against which figures were displayed. The backgrounds were like stilted stage settings for the action of human drama. During the Renaissance the compositional components were given equal emphasis and figures became part of the landscape rather than players before it. By the time of Corot, the figures were dominated by the landscape. This all follows the parallel developments of the philosophical thoughts of the Greeks and Western Christians.

Henry Hensche warned repeatedly that landscape painting is probably the most difficult of all painting, although it does not appear so. Painting the landscape takes more skill than figure painting because the painter must, besides creating the form, create the illusion of greater space and atmosphere not as much demanded in the figure or the portrait. Space and atmosphere are indeed present in the near proximity of the figure or the portrait; variety, however, is essentially reduced. The irregular forms of nature, complex color notes, and the difficulty of discerning where light and shadow fall in a highly textured atmosphere make the landscape master over the painter.

§§§

Landscape painting, when you think of it, is probably the most difficult painting. A figure or head brings to mind all the knowledge of form from ancient times to the present. Form was the most important area to master and endless hours and years

were devoted to its study. Any student who wanted to be an artist was put in cast class and learned to render the figure with proportional truth.

Parallel to the drawing of the figure from cast, anatomical knowledge was introduced to the art student. With all its complicated interlocking forms. And then they had to learn how they all functioned within the body. From this, the student graduated to the life class to learn the model in colors, in a value scheme, which was, more or less, a formula. The figure could be modeled in oil color and given the effect of light. All this took some time and was a formidable problem. When it was accomplished it was considered a great triumph and rightly so.

When pictures were first painted, figures were the dominant part and landscape forms were simply background against which the figures were displayed expressing human ideas. The background was like a theater curtain or setting for the action and ideas of humanity. You can think of Sasseta's works, the 15th-century Italian painter who painted Mary, Jesus, and Joseph. There you will see the use of the landscape in its final stages. The forms are flat and simple, and expressed with their local color, as Renaissance painters could do, and would continue to do. It was the figure that was rounded, as it was of primary importance. But as time went on, the landscape background became of greater importance.

A skill was developed to make the forms more complete. Often the figures were diminished, and the landscape took up most of the painting, until finally, like Corot, the figures were merely incidental and the landscape forms became dominant. The idea was that man was the most important thing on earth, on every part of the globe.

In another part of the globe, the Buddhist religion taught that man was only a small part of the scheme of things, and they considered man as a minor subject, expressing man's relationship to the vast landscape forms around them. And the figures expressed their ideas through gestures.

It was the Eastern artists who concerned themselves with the landscape. They saw the atmospheric effects of nature that created the moods of man, their psychological side. As civilization

progressed, they stayed in that art form until the opening of the new ideas of the Western world entered their society. While some Italian painters taught linear perspective, revolutionizing their visual experience, the "Old Masters" of Japan saw these Western ideas as a revolt of the young. This was comparable to the revolt of the Impressionists against the tonal painting of the day.

§§§

A painting teacher asked his students to paint morning landscapes and change canvases every two hours. This is is a hopeless assignment to develop the crude vision of beginners. His aim was correct, but the method was wrong. Its not the length of time of study that counts—the quality does. To develop a finer perception of color, you must teach descriptive color.

§§§

Always turn your study of the landscape into studied large masses until you've achieved the light key. This would be very few notes. Make them angular and then make the first divisions of color in each mass into a series of squares, rectangles, and triangles. This allows for easier study of colors as opposed to working the drawing too soon. If you don't do a study this way, you will sacrifice the color for the drawing.

§§§

Place a simple building in the scene. Treat it as just a block study with landscape around it.

§§§

Reduce the panorama of the landscape. We have a tendency to make trees too large. They will grow in your paintings anyway. Smaller trees will make your study of the larger color masses more effective.

§§§

In the beginning, you shouldn't try to paint a landscape that is completely lit in sunlight with almost no shade or shadow masses. This is too difficult for the student. Find a landscape with definite breaks between shadow and light.

§§§

All the young sculptors of Helenistic Greece saw the forms of the human body had rhythmic relationships that the archaic period sculptors did not perceive. So the forms became more real. The young men who discovered this, created the glory of Greek sculpture, like Praxiteles and others. They set the standard, which has not been surpassed.

The high point of the figure in Greece is equal to the discoveries of the Impressionists. The Impressionists reached similar perfection two thousand years later in the painting language.

Eastern civilizations did not make such progress, but they did give the first inkling of the importance of landscape and man's relation to it. The development of man's consciousness of what he was looking at, from using only the simple colors available to primitive minds, was the beginning. Gradually the forms were rendered more accurately, and the development of landscape forms was introduced, including leaves and flowers.

The more alert painting minds began to see the atmospheric effects. And they achieved this by varying the value of colors and created the illusion of distance. Parallel to this discovery, linear perspective was discovered. Now the landscapes were more real, or created that impression. If you look at this period of landscape painting, you will notice the first notation of great distance. In da Vinci's *Mona Lisa* you should notice the foreground to the middle distance—the distance is created by variations of earth colors. He saw more variations. And so, the modeling of landscape forms equaled the modeling of the figure. There was a consistency that others lacked.

When you look beyond the middle distance, however, da Vinci indicated the far distance with blues and greens. It was the

first step in the growth of man's consciousness of noting great distances, and the objects seen in them were bluish and cold. From this first glimpse of understanding distance came the idea so often quoted, "that all you need to create distance is blue." It is not that simple. Though it may be and is generally a fact.

Another generality is the often-quoted, "All you need to know is that light planes are warm and shadow planes are cold." And after that, the student of art can flounder on and invent his own nebulous and confused vision.

Landscape finally became an independent art and, as it developed, it affected figure painting indoors and out. Figure painting, when it is understood, has been affected by landscape painting. Man became as involved in getting the forms in the landscape as he did in the figure, rendering them solidly and in detail. Gradually it was the landscape that brought the consciousness of atmosphere into the figure. So even figure painting had distances indicated through value and tonal gradations.

So figure and landscape painting affected each other. In landscape painting, first form was rendered, gradually by means of value variations of the same color. Usually the local color. This is seen nicely in Inness, Turner, and the figures of Rembrandt and Velázquez. Turner, however, at the end of his life, added another dimension. He created the understanding of the "light key" and my notion is, if he had had the colors at his disposal, he would have achieved earlier what Monet eventually did a generation later.

Landscape became an art form independent of figure painting and equal to it. Van Dyck classifies paintings from the Greek point of view. He considered man the most important creation. Therefore, Raphael's *School of Athens* made up of Greek scholars was more important to him than Chardin's little still lifes, yet many believe that the Chardins have finer tonality than Raphael's or Ingres' works. For instance, after figure painting with people as subjects, he considered the portrait important. Then landscape, then, finally, the lowly still life. No matter how poorly it was painted or composed, he thought the subject should be considered first in artistic value. John Ruskin had the same point of view and the lectures of Reynolds indicate the

same trend of mind. So we ask ourselves, "What is the subject we like and want to paint?" In this case we have made up our mind that it is the landscape and need not apologize.

§§§

When you come down to it, landscape painting really takes more skill than figure painting, excepting anatomical knowledge. The landscape painter has to draw well, he has to know the character of forms, and it has to be modeled like the body. You have to compose as in figure painting, and so on. However, from my point of view, the creation of objects and the illusion of space is just as demanding as form knowledge of the figure. Despite its complicated and varied forms, a figure is easily seen in volume. Usually painted in distance, you can see the color mass of a torso easily enough. But, take a bunch of shrubbery, you find it is difficult to figure out where one form begins and another ends. Your mind has to perceive it like the hair on the head. Unless you understand the human skull, you cannot understand the masses of hair. Yet, landscape forms are basic and harder to find, where one begins and intertwines with another. All sorts of minor forms interfere.

And so the selection process of what form to pick first expresses the main mass, and then the minor forms that are related to the largest are more difficult. Most beginners realize this as they start. In a still life it is comparatively easy, and also in a human figure. In landscape, too, you have to know how one form flows into another, like the figure, to create the illusion of life. One must also learn proportional accuracy. You compose in-depth, as in the figure, and then you must add color key or atmospheric effect. This is the poetry of all painting. If you are interested in form—be a sculptor! Creation of form in the flat surface is not enough. It can be done in black and white easier because color is not needed.

§§§

Landscape painting, as Monet made obvious, is an idea that

affected all painting. With it he proved how the main actor in the drama of painting is the light key. And, the light key varies from morning to night and varies as to the kind of weather, and distance, and season, and probably according to the temperature zone you live in, as well as in the combinations of atmospheres. Monet discovered this while painting the coal-smogged air of London.

§§§

We have learned that landscape painting revolutionized figure painting. But figure painting must obey the laws of vision as well. The figure painter must also indicate the color key of nature if he wants to create the color harmony. If this is not obeyed or understood, you will make forms by creating your own color scheme.

The difference between modern color, or realistic color, isn't much, except the modernist doesn't obey the light scheme. But neither do most landscape painters. They create realistic forms but do not observe the laws of color and light. The decorative color scheme is a matter of what is called "taste" and need not copy reality. But if a realist doesn't obey nature's physical laws, he confuses the problem. In their ignorance, they defended their creative notions, in other words, they abandoned any laws that express truth. These Modernists should have listened to Einstein. Einstein said that God did not play dice with the universe. The great universe must have laws with its functions, and so does the art of painting if it wants to emerge out of the mystical period and come into the enlightened 20th century.

§§§

So here we are—our subject is landscape painting. We've put our easel in front of a lovely Cape Cod scene. The time of the year is fall, with all the varied local colors. The light key is gray day in the morning, in a high key. Now the problem is how to start a landscape. We proceed to draw the proportional characteristics with a crayon or a pastel. Having done that, we proceed

to lay in the colors, indicating the light scheme in a rough and general way. Keeping intervals between each area, select from the palette the color which would give the general impression of the light key. Also, remember the light areas should be light colors, and the shadows, dark colors. Each of the different groups should be similar in color value. The light areas, light color values; the dark areas, dark color values. Then, we make the first courageous attempt to create the illusion of what we are looking at. Also, while the colors are still wet, we might introduce a new color and mix it into the wet areas on the canvas and produce a more accurate mass to obtain a better image. In this stage we will find, perhaps, some areas of color in the light would be a bit darker than what you started with. The inappropriate variations would come about by the uncertain understanding of what you were looking at, as well as the colors that would interpret this still confused condition of your mind. Nevertheless, you go on, hoping for the best, and your interpretation will be confusing and experimental. You have to make a decision and introduce another color in the masses to get a truer interpretation of their relationships. You must rely on your judgment as to the color you will introduce into each area. You are an explorer, hoping to strike oil. It is like being in a boat, trying to anchor yourself to something solid.

You realize your vision is ahead of your color capability, and you desperately would like to get the ability to paint a quality of a white, or a blue, and so on. When you think of it, how can anyone give you a recipe for the flesh color of a person? It varies according to the local color of each object, which is different from that of any other. The color of the flesh would be different according to the light scheme it is seen in, the distance that you are away from it, and, possibly, other objects reflecting into it and affecting the mass of the color. Last of all, that your mind, being progressive in developing color qualities, would not express the color note of yesterday, and it would not be the same color you would express today. Assuming that you had, in a short period of time, a truer perception. One would hope that your perception would improve. Now, think about this and you will see how impossible it is to give a recipe for any color area. This

system is one based on progressive growth of the mind's perceptual possibilities. The keener your mind is in seeing, the truer your selection of colors. And here we can state that the finer or greater painters have developed a finer perception. We are always in a stage of constant growth and a better understanding of nature's visual phenomenon. We have the method now that was not known in the past. As the love song states, "It's no secret anymore."

It was a mystery for centuries. One wonders how those who achieved fine color qualities managed to do so. When you look at it you realize the great Venetian painters came into existence when the Italians were painting in the clear light, in the sun. The Venetians had the time to develop a clearer vision and put that vision on their canvases. When Monet came along, he also saw through the previous painters' eyes that were devoted only to the value system. His master was Boudin, who was his ideal. He soon outgrew this point of view, and stumbled around from the tonal value school for a more colored system, until he finally found his solid rock and tied his artistic boat to full color value. He revolutionized the "art of seeing." Of course, his method of arriving at that point was dramatic and it was the method of expressing light in color, and not value, to allow the key of nature to show clearly.

The landscape helped Monet determine how color expressing the light key was the first ingredient in a painting, not drawing. And now the problem could be solved as to how to pursue this. Today, painting study has become a science. I guess science means having a method, to follow a path. If you read about Monet's struggle for this realization, you find out that it wasn't handed to him on a silver platter. He had no one to go to. He was an iconoclast, destroying a past conception, but unlike others, he put a better idea in its place that has proven itself to be true. Today, it is a new language of visual expression.

One fact to understand here, as to what made it possible, is the augmentation of the painter's palette with new and varied pigments. More intense colors gave Monet a greater keyboard to express the endless varieties in the melody of nature. So he pushed our vision into the 20th century. Painting before Monet

was ancient, and after Monet, by those who understood it, became modern in the truest sense of the word.

The lack of understanding brought all the confusion in this era. The problem then came as to how to develop the technique to produce it. In the United States, it was Hawthorne who first realized that *color truth* was separate from *form truth*. The way you see an object is by color first, secondly by the shape, and thirdly by the edge. Before, the technique of instruction was reversed. First it was line, then filling the shape with local color, then varying the local color with white to get gradation and modeling. Black, or umber-darkened color to give the painter shade values. For some painters, the idea was prevalent that darks had no color, so the easy recipe was that black or umber would work in the dark. Yet, this did not create the vibrancy of vital visual images. But it was widely accepted.

§§§

In nature there are no duplications of the masses or their variations. And there are no duplications of color keys. At first, the mind sees the difference between the sunny and the gray day color key, and then, from there, you go on to more differences. A sunny day is the best key to study forms because they are more clearly seen. When you have achieved the noting of that key, you can probably go to perceiving the morning key until early afternoon. Next, you will be able to see a sunset scheme. From then on you will be able to tackle the different light keys as you perceive them. Before we see nature's symphony in all her varieties, we must master the technical ability to put down color that expresses the light that falls on the light planes, while holding the shadow planes in the dark. When we are able to hold the largest masses together in the general gray day key, we are ready to go on.

§§§

Looking at the still life series of the dishpan, it gives a clue of how we should start the study of our landscape. As I said before,

we first make a drawing of the basic patterns of the large color areas. Keep them more or less in rectangular shapes, which the color determines. When you are through with them and feel you have resolved this, then you can introduce the color into each area.

§§§

We are trying not to limit ourselves to value differences, but experience the whole of color expression.

§§§

If you believe the old teaching that blues and cool colors recede and orange and warm colors advance to the eye in landscapes, then your paintings will have a formula look to them. It is the quality of a color in relation to all other colors around it that determines its correctness. The only formula is to study the masses and then make the divisions within the masses which do not violate the truth of the mass itself. There. There is your formula.

§§§

Think of a tree or a shrub as a box, or a sphere, or a cone for study purposes. Block the lit side and the shadow side in the simplest way. If you paint the landscape reduced to its simplest forms in the proper light key, it will read as the landscape you are painting. Do not try to break the form into branches or limbs showing sunlight in the smallest places. If your masses are not correct, all the detail in the world will not help your painting.

§§§

How can you think of painting a landscape when you can't even capture sunlight on a box? Painters fool themselves more than the public when they believe their landscapes are wonder-

ful, when they really show no study beyond being just a picture. If all you want is a picture, go to K-Mart!

Proper study has its rewards. When you understand the color technique, you will never revert to muddy or lifeless color paintings. Patience has its rewards. To use this understanding, look at landscapes done previously by the "masters" and you will find very few see the different colors of the landscape.

It is our chance to enlighten the viewer, who, until now, was not made aware of the vast color changes of nature. Usually, people were content to assume that all landscapes were green, with blue skies. We have been exposed to a new way of thinking and seeing.

One has to, as Monet said, try to obliterate all previous impressions that you have been exposed to. Look upon nature as if you have never seen it before. Then you begin to climb from a savage state to a clearer and clearer elevation of the uncontaminated mind to one with wisdom and vision.

We are exposed to so many lesser qualities in painting. We are all "visual virgins" and we must search for clearer understanding of color notes. Mankind does not hold on to untruths forever, so we must educate the masses. Sooner or later we go to the truth of the matter. We want clarification and not confusion. And the arts, in general, at their best, lift people to a higher level of perception. Those who are capable will ultimately be honored for their efforts. Here's hoping that the truth will grow, but it can only grow if the performer produces this kind of truth. Mankind can grow if it is given the opportunity to see something clearer.

I believe, as Aristotle said, "There is no royal road to mathematics." And there is no "royal road" to fine perception. You have to want it and that will come about when you have trained yourself to see.

Good studies show you the means by which they were created. These studies do not hide their creative process. The more finished studies have more refined divisions. And we could probably take an untrained eye, like someone looking at the divisions in a Hals, who could see the solidity of the head. He could note the planes merging one into another. When we look at the *Mona Lisa,* these plane changes are hardly dis-

cernible to the naked eye. The untrained eye is fooled to think he sees forms by the model edges, not with color. This is true in landscape painting studies. Fool the eye into seeing form without edges.

So with the painter's eye, we see the early divisions of shapes. Then, as we grow, we see more and more into the color, and we know how they are created. By painting the large masses, which establishes the fundamental color key, we see more color. First the obvious and then as we grow we develop as to our ability as a painter. We grow at our pace.

And in the divisions of the color variations, in the mass, we can develop as many as we learn the skill to manage. It is good to have this power of observation. It is the same in music. You may want to render a lot of color variations, or a few. It depends on the composition and your interpretation of it. In the rarefied atmosphere, we may have only a glimmer, but the history of suggestion will affect our minds with the glamour of beauty and truth. As Keats said in *An Ode to a Grecian Urn*, "Truth is beauty, and beauty is truth." That is all you need to know.

§§§

A tree is seen as different colors under different light keys. It is not necessarily the local color of the tree. The tree may not be defined accurately as a delineated tree, but more accurately by a very few large mass color notes. Those few notes must express the light key or the tree is a lie. The simple, large masses of color must fit together to say this is a tree in such and such a light key.

Portrait and Figure

For the study of the figure and the head, Hensche stresses the importance of students doing block studies, anatomical studies, and sculpting.

For Henry Hensche, all study of color boiled down to the study of the block in the light key of nature. No head or figure was ever done with color clarity without the portrait or figure artist first humbling himself before the blocks. National reputation could not save an artist in Provincetown one summer as I watched her struggle and repeatedly fail. She had a television painting show, but her hours painting under the TV studio lights did not serve her well when she attempted to paint under the natural light conditions.

§§§

When we begin the study of the figure, including the head, we find that when putting a beginning student before a model, he is constantly torn in his mind between color study and the proportion. It brings you to the conclusion that you must separate the study of color from drawing and combine both later on.

Therefore, to study color it is best to take the less complicated forms; still life objects in scale, and obvious color, is the ideal study. Starting with the head or figure is not advisable. As Chase said, "Where there's still life, there's hope." Then, it is fine if you want to study the head and figure, but do still life first. It is especially necessary today if we want to master the art of painting the

head. The fact that *every form change must be a color change,* and the forms that express the head are so many with interlocking and complicated rhythms, it confuses the beginner.

In the system of under-painting, like Rembrandt and the "Old Masters" practiced, these problems were comparatively simple. All they had to vary was the value of a general color note to achieve rotundity. If color was added to the value it could easily be "injected" into the value. The color related to the value of the under-painting more than to the adjacent colors. Franz Hals' heads indicate this. He put bright red in his earth-colored base notes. And every one was more or less the same quality of red. Every Old Master added colors to his values depending on the accessibility of pigments. Some under-painted and glazed color on the dry painting, others added color immediately in the value to make form.

Today, if we are aware, we realize that what our painting forefathers did is now outdated. The Old Masters' limited colors restricted their capacity to express that which they might have seen. But I suppose most of them accepted this limitation. They convinced themselves that the color range they used was all there was available, and accepted it as final.

Of course, some did vary the color spots that flesh notes made. You see it in a Goya, for instance. Think of the fact that if it is true that every form change has to be expressed by a color change, the student has a greater and more difficult problem in observation. So I repeat, a still life object which is simple in form is the answer. If you cannot get or see color changes in a bowl, like a dishpan, when the form is simple, how could you figure out the intricacies in the shape of a head? The beginner who wants to paint the head should start with still life.

It was the Impressionists who brought this to our attention. What is basic is this: objects, including heads, are seen in the light scheme. The head, as seen outdoors, has to be expressed with colors stating clearly the light scheme in which it is seen. This makes us realize that one must study the landscape, or learn what is called landscape and its varieties of light schemes. Then we can bring the head into the same study of observing the different light schemes in nature.

§§§

When you start painting a portrait you cannot avoid the fact that the head reflects the light key. However, because the human head is made up of many different hues and tones, every head has to be observed as different from the next. The individuality must be expressed, but first one must learn to see the color changes in every light key.

Flesh color requires you to know the method as to how to express objects in the light key. The color of the flesh note on a gray day should be compared to a sunny day. It is difficult to see this change indoors, but it is there. This indicates that the mind has to be trained to see this as clearly as possible.

After you get this far in seeing the light key of the basic differences, you can now do what the landscape painter does, make more divisions. Then you are ready to try the head in color.

§§§

You do not create rotundity in the figure by sliding colors together. You change color notes to a gradation of colors distinctive to each plane to achieve the effect. Remember, every plane change is a color change—not a tone change.

§§§

At first, the beginner will find it difficult to express the whole color masses of light and shade. He has to learn to obliterate the smaller passages of form that indicate the eyes, nose, and mouth, which are confusing. If you pose the head in full light, this will be obvious.

It is best to pose the head partially in light and shade, like in a still life. You see the light notes of the flesh better if you contrast it with the shade. Here, too, you will find that the color of the light plane has to be expressed with the color note that best expresses the light. The shadow side of the face has to be expressed in the shade note. However, I would make you under-

stand that you should not tackle the head until you have developed the competence of expressing the unit of the whole note easily. Having achieved that level through an extensive series of still life studies.

The next level of seeing in studying the head is the indication of the light and the dark within the whole area of the hair mass. At this point if you can't go further than the basic first notes, repeat the study with another head. Then you can compare the two studies and see if you have gotten a difference of color between the two flesh areas. If you keep trying, you will soon find that you have accomplished the most important fact in doing a portrait. You will, at first, not be able to distinguish two flesh notes that look alike, but if you keep on, your mind will sharpen its observation and you will accomplish this. The distinction and variety will be observable by everyone.

After you have accomplished the elementary planes of flesh notes on a sunny day, use the same model and try to accomplish the same level on a gray day. If you can see these differences out of doors, you will see it when you come indoors. By knowing the sunny day and gray day figures are different, and trying to establish it, you will get the differences. It should be a revelation to you. You've added a new dimension to portrait painting. You will see in portrait exhibitions how this understanding you've achieved is not evident. The reason is simple, most have not been taught to observe this. People have been brought up to believe the flesh notes can be painted similarly on everyone. Nothing can escape the truth that all things are *different* in *different* light schemes.

You may wish to tackle the problem of painting the head in varying distances from you. The first step is awareness of aerial perspective of the head indoors. As the head is further away from you, it is probably smaller in size to create the illusion of distance, but illusion of distance will also be created by a color change.

Now we come to modeling the forms of the head. Generally, you'll find the basic divisions are harder to distinguish. Therefore, be sure to have distinct light and shade planes. Then you can probably see the half tone planes more easily. After this,

the division of each plane should be kept simple. Consider the head like an egg, leaving each shape relatively unencumbered. Look for the simple planes that would model it. However, the nose sticks out in the middle and there are holes for the eyes, and mouth, and other variations within the forms. In the beginning you should limit your observations to the egg. Later you can think of it like the anatomical student charts in art schools. Capture what is going on underneath the forms. You should at least try to hint at some of the differences.

Here another problem presents itself. How can one understand all the variations in a head and render them in color? You could forget all study of anatomical understanding and observe the variations of form through color differences. Let us say we look at the light plane first. See the distinct color areas and put them down in sequence. In that way you will achieve the form and you can continue to do so on the half tone plane. Then proceed to the shade plane and you will model a head very well. Perhaps it may occur to you that often color changes do not occur according to accepted plane knowledge—as some colors run across the structural planes, which becomes very confusing to the beginner. Now try to do a head without the study of anatomy and see what happens.

Here we come to another difference of opinion. Some say the study of anatomy is not necessary. Others claim that it is. Knowing the anatomical facts does not give you an idea of how to express a head in color. Michelangelo certainly knew the anatomy of the head, if anyone ever did, but his paintings were nothing but tonal varieties of the same color to produce the rotundity of the form. Nor did he indicate the light source. His contemporary, Titian, had anatomical knowledge, but used it to understand forms in light and expressed forms, then color and then value changes.

Remember the discussion between the two? Michelangelo accused Titian of not knowing the form while, Titian accused Michelangelo of not knowing color, and they were both right, each in their own way. They each developed different points of view. Titian was the painter and Michelangelo was the sculptor. You can notice the different approaches in their work.

§§§

I am of the opinion that you should take Fine Arts and find a good sculptor to help you study the head and human body in the round. Learn all about the skeleton and learn all the forms of human construction. Learn the origins and insertions of the muscles, and their volumes; characteristics that are typical of the human body. Then you can go on to the action of the limbs and other masses. Having acquired this knowledge, you are now able to give your figures greater action, different poses, and use this anatomical knowledge to give facial expression. When the whole unit is complete, your paintings will express the complete human experience of emotions.

Also, a good sculptor would teach you how forms of the human body have what is called rhythmical flow of form. The Greeks in their great period made the skip from archaic forms to the living quality of sculpture. This was due to the understanding that living forms intertwined and flowed rhythmically. The study of sculpture makes this understanding clear, and you can use this as you paint and model with color. It makes the student look for the "shape truth" in color notes. And add this to their relationships so the action of expression can be given. It seems to me that it is advisable to study the figure, as I have indicated here.

Now go on to what is absent in the figure and portrait and that is how color can suggest the mental state of the individual, the psychological state. We react to color keys and this should be used to describe an individual or suggest one's character. If we want to express hope, perhaps a spring-like color scheme would be best; one of solemnity, a darker or gray day scheme would do, and so on. This has not been made use of in the art of portraiture. The seasonal variations and kinds of days as well as the local colors in their schemes should open up a whole new world for the painter to explore.

Hensche on Seeing

*Henry Hensche believed the growth of a student's painting abil-
ity was inexorably connected to his visual growth. Visual growth
would lead to visual realism. While other schools taught realism
of the classical and the neo-classical schools, Hensche redefined
the word "realism" in terms of visual parameters and not sub-
jective tonal realism.*

*For Hensche, light key was the backbone of the painter's craft
of realistic representation. For art to arise from the level of craft,
its effulgence would be the result of the Hawthorne-Hensche
approach to this new color realism.*

§§§

An opinion which has been stated again and again about the
art of painting is that realistic painting has been exhausted. This
common fallacy exists among writers on art, and the student
body. The modernists believed the photograph has replaced the
need to paint things as they are. This is not true, for the camera
does not reproduce an image the way it is seen by the human
eye, which is controlled in its selectivity by the human brain.

The higher the degree of perception, the wider the gap
between a cultivated realism and a mechanical one. The world
is more beautiful and has much more subtle coloring than the
camera can capture. Unfortunately, there are a great many
painters with uneducated eyes who try to emulate the photo-
graph, who even copy from it and produce work on the same

common level with no higher appeal. In this sense, the photo-graph has corrupted the vision of man.

The truth lies in man's visual perceptual growth and it is this phase of the history of art that is the most valuable to the painter. The steps by which man has achieved greater clarity, a greater orchestration and variation of color quality and refine-ment, was fully understood and taught by my teacher, Charles Webster Hawthorne.

He made it possible for his students to learn to see and con-trol color, step-by-logical-step. He gave us a principle upon which our work grew naturally as it extended our vision, quali-tatively and quantitatively. He called it putting one spot of color against another to represent the truth of the color and the light. This was the beautiful and basic reality of what we had seen and he made us aware of the different states of vision of the various students, ranging from the very crude to the very sensitive.

Our first objective is to state the light scheme, the key, in which the figure or object is seen. Secondly, the distance between the student and the object, the local color of the object as changed by the atmosphere around it. This is all possible when the color relationships are acutely realized.

Hawthorne used Monet as an example. When colors were available while he (Hawthorne) was in Chase's class in Long Island, he said, "Wait, I will look on my canvas and try to make my color truer and not immediately make the shape with ill-considered color." As it is with drawing, it is also true with color: the first impression is not the final statement. So he reconsid-ered the color and studied it to make it truer. And then the color of nature was studied as he developed his method. In this process, the realization that color perception is a gradual devel-opment was born. Color studies must be made until the color that best expresses visual truth is evident. The image of color relations must be so true that average minds, not contaminated with wrong objectives, will give the truest interpretation of the light key. This is achieved by sticking to the mass areas until they have truth.

In the process of achieving this we stumble around. But if we know our objectives, we finally reach it. Many can't wait to

develop the essential masses to the level of perception that I have indicated. They try to develop form incorrectly, and model too fast, without getting the light key from the beginning, and try to get too much detail too quickly. If the large masses are not on a high level, the division of the masses is gone into too soon. The result is usually a duplication of the variations. As a result, it destroys the mass.

The understanding and study of the color masses was Charles Webster Hawthorne's great contribution to the teaching of color. Unfortunately, not one of the major art schools has taken advantage of this sound method of instruction. They leave color development to the individual student as he flounders around unaware of a goal or a path to it. His intuition is not enough to guide him, and the automatic color systems the schools may teach are of limited value, even in the commercial fields.

Only the education of the art of seeing, unique as it is, supplies the possibility of continuous growth. As a good music teacher makes the pupil aware of finer sound tones and how to produce them, the good art teacher will make his student aware of finer color tones and how to put them together.

§§§

Any system which does not explain reality satisfactorily is discarded by mankind as soon as they realize it does not reveal a truth which can be proven. So many have concocted systems which proved worthless and have been discarded.

It is amazing that, fifty years later, art schools are still teaching antiquated tonal painting; schools that insist that drawing is the foundation of painting. Matisse said, "You must learn to draw as I do before you use color." The foundation of painting is not drawing, but understanding related color masses and this requires an entirely different skill from the proportional one of drawing.

Charles Webster Hawthorne was teaching color painting during the summer in Provincetown, Cape Cod, when I joined his class and happily settled down to the serious study of color painting. After a while I grew in understanding of what I was

trying to do, and the reason for not tinting with my paints but applying them with greater strength. This technique was a means to an end, not the primary purpose, which was to see and render objects in space and light by color variations.

The obvious fact is that you cannot see an object except as it exists in the light in which it is seen. As the sun travels across the sky the same object is seen at the same distance at different times of the day. It is seen by a completely different color combination and must be expressed by the artist who must be aware of the new relationships before he can record them.

The tone painters could not understand this, for they had painted by formula. The color of a white in shade might look like a blue to an Impressionist, but it would look like a gray obtained by a toned-down black to a tonal painter. If you look at a white in shadow on a sunny day with an unprejudiced eye you will see it is some kind of blue. The quality of the blue used, its refined justness, reveals the stage of development of the artist making it. He begins with a flat mass and modifies it as he makes comparisons and adjustments with the other masses of color, recording his light scheme. The big masses are most important and these he improves as much as he is able before making variations in lesser areas.

It is mainly a new technique of seeing by color differences and not by tonal differences. Undoubtedly, there have been artists of previous generations who saw colors they wished to make but could not because the necessary pigments had not been invented. Leonardo da Vinci wrote about this experience and knew his vision was far ahead of his time. He knew he could have built an airplane, had the engine and fuel been discovered in his day. Often theoretical knowledge comes long before the practical knowledge needed to make the models of the idea.

In painting, too, there were artists who were unable to fully express themselves in color. It is the imaginative quality of man that advances the whole human race, and this is necessary in painting, too. There are never enough men of imagination in any field to carry the race another step in its progress.

But this the Impressionists did. They showed mankind a world of beauty hitherto unseen and unrecorded. They

increased our visual experiences and added joyous awareness to the world around us. A great gift has been given to us all to share, by a very few men intently searching for new aspects of beauty. Monet knew that he was seeing something new that past generations had missed, he suggested the illusion of sunlight; which men before him had tried to express, but not successfully, no matter what technique they used.

It was a new way of seeing and was not confined to sunlight, but sunlight is easiest seen and studied. Monet was aware of the complete change of color scheme and either packed up his paints and returned home, or took out a new canvas and started a new scene. He and the other Impressionists became aware of the wide range of painting keys, sunny, misty, light gray, dark gray, foggy, stormy, twilight, sunrise, sunset. The enchantment of such variety enhanced their simple themes and revealed to us the unending importance of light and air.

The most important thing to remember about the Impressionist movement is that it was the maturing point of the color language. For the first time in history, a full range of color painting came into being. Man, instead of using a limited antiquated form and a convention unrelated to nature except in its tonal values, was for the first time producing real color painting. This is the way we really see the world around us.

§§§

In the past one hundred years we have developed our alphabet of color, and now we have a language capable of expressing anything man is able to perceive. The development of painting is dependent upon perception. It is a question of how far the human mind can be developed. I doubt if there are any limitations, or if there is one, it has yet to be reached. The argument that contemporaries make that the Impressionist movement was a peculiar one to its time and to Monet is ridiculous when it is correctly understood. It is actually the maturing of the language of the descriptive powers of color.

Now we have it. It is similar to adding new words to the dictionary. That does not make art, but it enriches the language. A

richer language is the result of more perceptive minds searching for a more exact way to communicate with others. We have the colors today to make it possible for artists to reveal new concepts of nature. A dull mind, with limited vision, is content to use very few colors, often as they come straight from the tube or the house painter's bucket. Unless an artist penetrates nature's moods and colors and sees beyond the average person, and can reveal this through his paintings, he has no function in society.

In other words, people are not interested in what they already know. They want to see something develop from the Impressionist movement so that it was not just for that short period when a small group of men struggled to clarify the vision. This is just like saying that the English language has reached its maturity so it should be scrapped in favor of a new language.

This brings up the question of why man does not grasp any basic idea the first time it is presented to him. He prefers the simple, everyday words to tell it again and again until it becomes thoroughly familiar. Any student looking for a neat little recipe of how to create a masterpiece in six easy lessons is warned he will not find it. I point the way to better painting, but it is you who must work to achieve mastery, step by step. There is no "royal road to art" in any of its forms, and often the only reward is the realization of progress. This seems unjust, and it is, and it will remain so until an appreciative public comes into existence. Meantime, the artist has the inner satisfaction of his own spiritual and cultural growth. This is a blessing millions will never know.

§§§

The normal conception of realism is completely false. People think of realism in terms of the delineation of objects. The beginning painter often relies on rendering the form. This is his convincing reality. It is also the easiest way to create an illusion of reality. In fine realistic painting it is the color key, simply because it is impossible to see an object outside of the color scheme of its light.

§§§

In the beginning, a student would see the darks as very dark and the lights as very light. Later in his development he might find one large note and push it to the finest color he is capable of. This note should maintain itself as a mass with no variations. Then, work the other notes adjacent to the original note. Remember to work rapidly and make quick decisions. The colors surrounding the original note should have a quality of the original note because they have been keyed from the original note. Now, the student is ready to make adjustments to all the major mass notes.

§§§

Painting is a means of developing your mental aesthetic life. You don't ever do paintings for money. If you paint to sell you are no good. Worthwhile achievements are not done for money, they are done for the love of study. You do them for self development. Selling is a by-product.

§§§

If you are looking for painting techniques you will not get them from me. Techniques give you a predetermined solution to your problem. In the end, there can only be visual analysis. Without visual analysis you will experience no growth. You will return to the pat solutions some teacher gave you and you will revert to mere picture-making. If there is a "Hensche Method," and there isn't, it is simple. Paint the large masses of light and dark true to their color relationships in the light key in which they are seen. When this is done well you then divide the masses into the divisions of the variations of color within each mass. When you no longer see any divisions, stop. You have reached the end. This pattern can be learned quickly, but you'll pay a lifetime for the color quality to paint convincingly the light key of nature.

§§§

Hawthorne constantly warned his students about making "pretty pictures." You can do like Rembrandt and take a side of beef and paint it well. That will be more beautiful than a badly painted bouquet of flowers. Anything is painter's fodder. Don't waste your time looking all over the place for pretty "things" to paint. Paint the proper light key and nearly all things can be beautiful.

§§§

Give your viewers something more than decoration. Give them something that will raise their level of vision. Let them see a new beauty through your eyes.

§§§

It does your painting no good to put all kinds of details if you miss the main point. Get the light key and the details will take care of themselves. They are not important and eventually you will see how they make your paintings look foolish. Your paintings will look like craft paintings.

§§§

You do not need to do what Monet did exactly. In his *Grain Stacks* series he proved the different light effects could be painted convincingly. We do the same with colored blocks on a table top. Blocks painted by a beginner could show the simple differences of a sunny day versus a gray day. By painting the blocks under a large variety of conditions (early morning, hazy-bright day, late afternoon, early evening, misty day, etc.) and comparing these differences, by noting the color note of the masses alone, you could master what Monet did.

§§§

Compare what is near you to what is far away. There isn't any way you can be seeing correctly if the grass at your feet looks the same to you as the same kind of grass 100 feet from you or a half mile away. If you paint it all the same at the end of your painting session then your grass or whatever it is you are painting will look like a poster board. How do you know things are at a distance from you? Simple, there is a color change between things near and far. Now that you know there's a difference, paint the difference.

§§§

You cannot fully develop your vision by painting in a studio all of the time. You must get outside to learn to paint correctly.

§§§

It is the illusion of reality we are creating. Our illusion by painting the light key of nature is truer than the tonalists' because we are seeking truth through the relationships of the color notes. The tonalists rely on line to draw first. There really aren't any lines in nature. Read Hawthorne's notes—only a color note touching another color note. Then the tonalists see the world like a black-and-white photograph with a color tinting applied. Others call themselves colorists. Truth is that anyone can slap pretty colors on a painting, but can you place colors in proper relationships to create the illusion of reality in the light key?

§§§

Each time you stand before a blank canvas you have to think you are going to solve a visual problem and not make a picture. Reduce your visual problems to ones you can handle. Make the first notes large and simple and continue with the painting as a study in mind. You will succeed if you approach every painting in this way. You would be wasting your time if you did it any other way.

§§§

Scan the entire area you are painting. Take quick looks across your subject. Look fast and get the sum of the whole in mind before you begin. We tend to focus and narrow in on one small area to start and stay tight for the whole painting.

§§§

Staring into one spot too long will cause you to eventually see all colors. You must pick one color to state the mass note and then go on to another area.

§§§

Don't mix what you think are refined colors on your palette. Change your colors directly on your study and not on your palette. You can't make a decision on how one color relates to another by mixing it in isolation from the other colors. You will make your decisions as you are changing one color next to another color. That is what Hawthorne wanted his students to do. How else will you know if that color is correct? You must see it in direct relationship to its adjacent colors.

§§§

If something looks like it is sticking out of the painting, that is a sure sign you did something wrong. Bat it back into the rest of the painting. It probably means that you took the thing out of the mass. It is a division that does not belong. I can't stress enough the importance of holding to the masses. Your painting is not visual truth if what you did was to contrive a scheme by which the parts don't fit the whole.

§§§

The public can be fooled, but they will recognize the truth when they see it.

§§§

You can't really paint what you see. God has a better palette. You have to paint with the colors you have in the relationships you see. This you can do. You have to paint what you have learned. So learn well!

§§§

Don't use the white of the board or the canvas as a color. This is something watercolor painters do. You can't study with all this transparency. Make solid colors.

§§§

No person should ever fear freedom of expression in the visual arts.

§§§

Schools are about mind control without much inspiration. Look at them. They require that you conform to their truth in practically everything.

Give me a student who has never studied in an art school and he will become a better painter. That's simply because he won't have to unlearn so much rubbish he was taught by others.

§§§

Never work to the edges too quickly. One reason why I want students to keep away from an edge as they study color is because they will revert to drawing the object with color. It is the reason why Hawthorne made students use knives to paint. We don't want to draw with color because we are falling back on design and draftsmanship rather than achieving proper color relationships.

§§§

When you look at a landscape or a person posing for a portrait, you must see them first as the still life block studies. The knowledge applied to any subject is the same as these block studies.

§§§

Art can make life beautiful. Believe me, it is worth the effort to achieve the highest level of seeing that you are capable of achieving.

Hensche on Hawthorne

Henry Hensche's steadfast devotion to Charles W. Hawthorne remained to his final days. There were times when all he wanted to speak about was Hawthorne. On October 30, 1988 he told me, "I want to talk only about Hawthorne now."

§§§

Hawthorne did not belong to any group intellectually. He didn't belong to the (Robert) Henri group which gave expression to the face. Hawthorne wanted to give color modeling to the face. He never solved the problem of individual expression even in the relaxed state. The women were all staring out of the picture with innocence and open eyes. The mechanics of expression were beyond him, but not the modeling. I don't know of anyone who saw as many color changes in an area as Hawthorne. The difficulty was how to put them all in order. Sculpture helps to organize the big area relations to the small spots. There is a rhythmic relationship evident in which Hawthorne never had any instruction.

§§§

Although he belonged to the National Academy and other organizations, Hawthorne was not interested in leading any of these clubs. "The Eight" was dominated by Henri, who was Hawthorne's rival. Hawthorne was excluded from the Armory Show, which puzzles me because he was open to new ideas.

§§§

Henri was William Merritt Chase's assistant before Haw-
thorne. Henri didn't get paid for some work he had done for
Chase at Shinnecock. When he refused to be Chase's assistant
after this incident, Chase picked Hawthorne as the new assistant
instructor. No doubt Henri thought Hawthorne had connived to
the position and held it against Hawthorne from then on.

I got the venom of Henri once because of it. I had a 20" by
24" sunlight sent to the Academy for jury and got an "A" for
"Accepted." You could also get a "D" for "Doubtful," meaning
subject to recall, or "R" for "Rejected." My painting got an "A"
with both Hawthorne and Henri on the jury. Henri wanted to
reclassify the painting to a "D" after he found out I was a
Hawthorne student. Hawthorne would not let him because he
knew that Henri was just trying to get back at him any way he
could.

§§§

Hawthorne did not believe sculpture was necessary to the
development of a painter, but the more I painted and thought of
it, I thought it was essential in two ways. You get to know the
form better, and, if you know the forms in their rhythmic rela-
tionships, you can model the face in a logical sequence of one
rhythm to the other.

The Greeks solved that problem around 400 B.C. when their
sculpture reached its height. German excavations found an
inscription in which the Greeks called it "the rhythm of form
movement." Before, they saw different forms but they were sta-
tic in their relationships—they didn't flow one into another.
There is a difference between living things and architectural
things. That living things have a continual flow of life rhythm is
what the Greeks like Praxiteles and Phidias developed.
Modeling was taught and understood by Grafly of Philadelphia.
He produced the great students: Walker Hancock, Demetrius,
and Polasek. They took the bone structure and added the flesh
masses with the skin. Once you know how to model in this pro-

cedure it becomes a dance between the bone structure and the flesh notes. It is the bone structure which dominates the outside form. They all work together. The more you understand this, the more you can take advantage of it to model the face and give expression to it. With this knowledge, the painter can put color in the direction of the flow of the form and take advantage of the light source as well. It gives you a plan of how to paint the head in a rhythmic relation of a form or flow that gives an expression to an idea. This is something that Hawthorne didn't quite achieve.

§§§

I was painting a 92-year-old lady in the South one time and the family told me they wanted her eyes opened more and with a twinkle in them. I told them you can't make the eyes twinkle without closing them a bit more. The eyes must be squeezed. You see, doing the head with action and expression is quite a complicated thing. When you do know the volumes and how they flow together you can get an expression you can't get any other way. Velázquez did it. He did get action of the face, but they still don't have the delicacy of modeling that is possible. If only he had known more about structure, but I can't go around attacking the great ones.

§§§

Hawthorne was interested in painting subject matter that was appealing and, for a while, he wanted to paint nothing but "madonnas" because of his interest in Italian art. He enjoyed painting the women of Provincetown and the fishermen. He got this idea from Franz Hals who painted similar things in Haarlem.

§§§

In the realistic painting world of Hawthorne's time there were

still many mannerisms. The painting world split into realism and abstraction, and then all kinds of experimentations.

Hawthorne could see what was happening and revolted against it. Modernism had nothing to do with his sense of reality. But it became overwhelming when the Academy succumbed to it.

§§§

Hawthorne tried to make color truth and not draftsman's truth. People drew with color first. Hawthorne could make color flesh notes like no one else. Compare his heads with other painters' heads and you can see it clearly.

§§§

Hawthorne was strongly influenced by Titian and the Italian Renaissance. He later was in touch with Impressionism but didn't understand it at first. He could not paint with firm conviction the time of day. He only went as far as showing the gray day and the sunny day. I went further by showing the difference between a sunny day and a gray day, even in the north light of the studio. Hawthorne never saw that. He knew it existed, but he never could see it. He remained the master of the figure indoors.

§§§

Some things mystify me about Hawthorne. I know he was held in high esteem by the painting world because when it came time to dedicate a bust to William Merritt Chase at the National Academy, it was Hawthorne who was asked to do the dedication. So why is it that the only book ever circulated on Hawthorne is *Hawthorne on Painting*?

The book was compiled by Mrs. Hawthorne from the notes taken by a sister of a deaf student studying with Hawthorne. She studied four years and the notes were supposedly taken during

those sessions. Mrs. Hawthorne asked me to read the notes to
see if they agreed with mine. They were accurate.

§§§

Hawthorne's generation was the first to sell American
painters' works to American galleries. Before this time,
Americans wanted European paintings. Because of this he was
getting wealthy on portrait commissions alone, but it never
stopped him from teaching in the summers.

§§§

At the Chicago Art Institute I had first heard of Charles
Webster Hawthorne after I had admired the work of fellow
Chicagoan Frank Schwartz, one of Hawthorne's older students. As
Hawthorne's third studio assistant, I was allowed to teach without
supervision and had to develop a method by which Hawthorne's
teachings could better be understood by the students.
Hawthorne's second studio assistant, John Frazier, was not really
as interested in Hawthorne's teachings. He was an instructor from
the University of Kansas, more interested in the later paintings of
Velázquez, and did not develop a full understanding of
Hawthorne. Richard Miller, who also taught at the Cape Cod
School of Art, would start with values composed very nicely, but to
him Impressionism was putting complementary colors on top of
value-based colors. By doing this he got a "coloristic feeling."
Hawthorne did the colors right off the bat. Miller never got aerial
perspective. Hawthorne didn't get it to the degree he should have
in color. At least his color was not a complementary color; it was a
particular color. It started from the fact that people didn't know
what to do when they looked at color in nature. They thought the
color plane was warmer in sunlight and the shadow plane was cool-
er. Most people thought Impressionism was a matter of cool and
warm colors. They believed you substitute purple shadows for
umbers and blacks and that would give you the Impressionist
"look." Miller didn't know better. Hawthorne didn't know better at
first either. He said it took him 15 years to understand it.

§§§

When I came to Hawthorne to study, you could tell immediately where the students came from by their colors and shapes, which were so distinctive that you didn't have to ask who taught them because their paintings showed it.

§§§

Hawthorne didn't study the landscape so he couldn't have a consistent color key indoors, which is more subtly seen, but you certainly have to know it is obvious in the outdoor light. Hawthorne said students should paint in the outdoors, in the most brilliant light, because there nature separates itself in light and shade. Furthermore, you see the light keys. You learn in direct sunlight that the color which expresses the light is entirely different from the color which is expressed in the shadow. Indoors that is not so easily seen. There is every reason to paint out of doors. Hawthorne recognized this. He got people to paint in the right color and it was also the right depth and value. If you don't understand this in practice then people who talk about teaching color think of getting values first. When they get the correct value then they add what they believe is the correct color over the value. That proves the mixed-up state of people.

Hawthorne was not yet to be clear on this himself when I arrived in Provincetown. I decided to settle it for myself, and when I did teach that way it was an analysis of what Hawthorne taught—the prudence of holding the masses until they expressed the light and shade and then you started making the difference of a sunny day and a gray day. Those are the first color differences of key and then you would split the day into different hours.

When it came to landscapes, he alluded to different times of day but never refined the paintings. Most of his landscapes were done *alla prima*. The others he never worked more than three times on them, usually twice. He didn't trust the fleeting light. As his student I was afraid to do landscapes, because I felt like Hawthorne, that the indoor light was so reliable. Eventually I

brought to the attention of the class the importance of studying the outdoor still life and taking junk (old shoes, pots, bricks, and boxes) instead of fancy things.

§§§

By the time I arrived, he achieved the large color notes, but not the correct color key. He could only paint the sunny day or the gray day. He never taught it but he understood it. Nor did he practice it on the figure. He could get the color notes of the flesh, but didn't catch the light key. He had not finished the experience. In practice he went further. His watercolors prove it.

§§§

A student who studied with him in 1914 told me he was teaching the pointillist system before I came along five years later. I know he was apparently still working on the idea when I came because he once worked on a head of mine and he stippled it with dots even as he was speaking of main notes. But I came to him when he was finally making sense of the Impressionist movement.

Hawthorne never spoke of pointillism, but he had to have done it to get a broken color scheme while he was studying the Impressionist movement. Chase never gave Hawthorne a clue, because Hawthorne had to figure it out all by experimentation.

§§§

While he was in Paris he shipped boxes of his paintings to Provincetown. I was there when they were opened. They looked vigorous but stiff. He went from being a value painter with an aerial feeling to the full color range. They lacked luminosity. But he improved on these in the next fifteen years. His period of fulfillment in the full color range was from 1915–1930. He was becoming a color painter. You could see it in these first paintings from Paris.

What he never did in the landscape was to go the route of Monet. Since I had many hours to myself, I decided to develop

the landscape where Hawthorne didn't. So I painted the hills of Provincetown with their many bushes. These I had to learn to hold in the large color masses. Even Monet didn't quite solve this, because if you look at the landscape in the Boston Museum of Fine Arts you will see there are bright orange bushes on the top of a hill. He couldn't hold them in the atmospheric conditions of the rest of the painting.

The test comes when you have many things close in front of you and you can pick the key to which they belong.

Hawthorne would paint a flesh note indoors the same in the morning light as the afternoon light. And then the same on a gray day as a sunny day. In a sense, he disregarded what he knew was there and created a "Hawthorne color scheme." His backgrounds were even detached from the figure. He did know better, but he never felt he could invest the time necessary to achieve the fine distinctions of the light keys.

§§§

Hawthorne would howl when a student lost the main note. But he didn't really have a way of teaching this. I came along with a still life process to analyze what he was instructing. I instructed the students in this process behind Hawthorne's back and was afraid of what he would have to say once he saw their works. He agreed with it right away and I knew I was on the right track. I had to come up with something practical for the students because Hawthorne hadn't. He solved the problem of getting rid of the value scheme but went no further. He had not worked it all out, because to do so would require him doing landscapes to get the harmony of color.

§§§

I started the students on still life out in the yard. Hawthorne only had the students paint the figure out of doors and they would go out and do landscapes on their own. Some did get a quality of difference in the gray day and the sunny day, and a few, the late afternoon.

At first the students who were painting outside got nowhere near the variety of light schemes possible. But I knew they eventually would.

§§§

Hawthorne went to Holland, Italy, and then to France where he met Richard Miller. He would have stayed longer but the war broke out in 1914. He lured Max Bohm, Jack (John) Noble, and others back to Cape Cod from France.

§§§

I happened to be in Paris in 1921 when there was an exhibition of figure paintings. There was a Hawthorne in the show of a young girl in a white dress. It stood out in the show because it had a better color reality than the other paintings.

§§§

If you look too long at an area your eyes get tired. The warm reflection is an entirely different color from the cool reflection. If you look too long you see the complement. This illustrates the importance of looking at the unit of the masses. Hawthorne never put this in words. Had he done so, we would have understood color much sooner.

At the end he, was grappling with the color of the Impressionist movement. He didn't want to let this problem go, but he really had not solved the problem.

§§§

When it came to psychological expression, I had the nerve to talk to Mrs. Hawthorne and tell her how I was impatient with Mr. Hawthorne's drawing and painting of expression. He painted people with emotional detachment. I didn't want to criticize him because I was in the growing process. I thought he could at least give emotion through the expression of gesture.

This must have gotten back to him because one day, shortly after, I was in his studio observing him. He had this Portuguese girl posed looking down at a baby. Hawthorne looked kind of angry and the next day even more so. On the third day he exploded. Looking at me he said, "What's the use of painting the head if you can't paint the eyes?" I thought it was foolish for him to say that. He never tackled this problem again. He had a difficult time doing anything but frontal and three-quarter portraits, but his pencil drawings were very delicate—like Holbein. The last thing he did was to put the line.

§§§

Critics claimed Hawthorne's subjects stare blankly out of his pictures. It is true, but his figures have a tenderness and refinement you will never find in a John Singer Sargent.

§§§

Hawthorne had the highest regard for the work of Abbott Thayer. It probably was the solidity of a Thayer figure compared to the dashing brushwork of the celebrated Sargent. You could say it was a reactionary thing. Hawthorne was willing enough to embrace new thinking and vision, but his admiration remained for the well-rendered head. He believed a kind of perfection was reached in the Renaissance and the Thayer women must have reminded him of the period. However, the difference between a Renaissance head and a Hawthorne head is dramatic. Hawthorne's rotundity was achieved by color changes with plane changes. Renaissance painters made beautiful tonal changes with the plane changes. This was the best of their vision since their painted observations were limited by the tools of their time. Specifically, the limits of their palettes.

You can see the evidence of the revival of interest in the Renaissance by looking at just the frames on paintings of Hawthorne's period. So it wasn't just Hawthorne, but many of the portrait painters of his day were looking to the period as the apex of art. To Hawthorne's credit, he continued in his interest

in the latest developments in painting. However, he never did understand the *avant garde* movements of the early part of the century. He said about Titian, "He could paint." That simple statement is probably Hawthorne's way of saying that "The Eight," and all of the works at the Armory Show (1913), were not on par with anyone who "could paint."

§§§

Hawthorne struggled between the naturalistic painting he'd become famous for and the new vision being spread to the U.S. by so many painters going to Giverny. Even MacBeth Gallery, which handled Hawthorne's works, was critical of Hawthorne trying new ideas. Of course, MacBeth was trying to satisfy patrons.

§§§

You never see Hawthorne refer to Monet in his book. He understood what Monet stood for but never really practiced it. You can't fully understand anything unless you first practice it.

§§§

One evening after Hawthorne's return from Europe, in 1929, we had dinner together and he asked how the summer teaching came along at the Cape Cod School. It was then I told him that I would never have gone on with painting if I hadn't met him and learned what I did. To me it seemed so logical and beautiful. I was really thanking him for the first time. Also, I thought the world should know what he was teaching on the Cape. He looked at me quietly and said the most beautiful words I've ever heard in my life: "You know, Henry, I think we have something here." He said "we." He knew it was a collaboration. He was the discoverer of the complete color system of painting. I made it teachable, but he was the initiator of the idea. In the higher planes of ideas, very few people understand genius. With all the genius about him why didn't the idea develop sooner?

§§§

Mrs. Hawthorne scratched out some of Hawthorne's works after he died and gave them to me to use them to paint over. I didn't want to paint over them, nor did I have room to store them so I eventually sold them to the owner of a Provincetown pub. I sold three for $1,000 and gave him three more. I had 30 or 40 at one time. Some I gave to relatives. When Walter Chrysler came to town, he wasn't interested in Hawthorne because he had never seen his work. He wasn't interested in portraiture either. But when he saw a drawing of mine he thought my work was next to Michelangelo's, so he got interested. I eventually sold him one of my Hawthornes for $1,500. I thought Ada's (Ada Rayner, Henry's first wife) relatives would have wanted them, but I sold the others to a gallery. All I had left was the head of me, a landscape, and the Grosvenor portrait. Hawthorne had sold almost everything before he died. Hirschl and Adler peddled some of his work. They didn't want to buy my work, but when they found out I had some Hawthornes they wanted them.

§§§

With Ada's help, I came to the vision that you had to make a different study indoors when it was sunny and again when it was gray. I went so far as to do a portrait in the very late afternoon. Hawthorne didn't see two different color schemes in the north light and neither did Sargent. Unless you are very highly attuned to light key you can't paint it. It is a closer harmony and unless you are a landscape painter attuned to it you will not get it in the portrait, the figure, or in the still life. I wanted to push it further than Monet. Monet struggled with the basic problem of light key as he struggled with new colors from 1860 to 1885. After twenty-five years he finally proved different light schemes could be painted with greater clarity. This he accomplished in his series paintings.

Hensche on History

In our first tape-recorded conversation, Henry Hensche tried to summarize his nearly sixty years of learning based on the history of painting. His patience for the uninformed-but-willing is noted by the deliberateness in which he structured his case for what he thought was the obvious.

It may be that he packaged his "pitch" for all the artistic "unwashed" and he was ready to sell his ideas to any who would listen. Hensche begins with a shocking conclusion and then builds his historical case. He calls for a painting Esperanto with a depth and variety wide enough for every expression.

§§§

We have finally reached the stage, after centuries and centuries of man living in this earth and painting in the last one hundred years, that we can discard former methods of painting and consider them *passé*. They are erroneous. They are not true now, but they were the best our ancestors could do. What I mean by that statement is perfectly simple. There is only one way to paint. That sounds very drastic doesn't it? You can prove it.

Before the Impressionist movement, the realistic painters created the illusion of reality with the pigments available to them. Rembrandt, for instance, had only a certain range of pigments. Between 1860 and 1870, many new pigments came into use. Everyone who painted (including Titian, Vermeer and Velázquez) had his own system of creating the illusion of reality. Some had much more color in their values than others.

Vermeer's *View of Delft* looks like a gray day, but it is not a gray day in the sense that I can paint it or anybody can paint it. We knew better. It is gray in the general sense—like Corot's trees are grayish. He also had the sunny day. Those generalizations of the two general color schemes had been achieved long before Monet came along.

They had different notions of creating the illusion of objects in light. They were very skillful men and women. How could you say that Titian was not a great painter? He was. So were Velázquez, Rembrandt, even Chardin, the marvelous still life painter from France, and Gainsborough in England, for that matter. Of course, you must include Turner and Constable who preceded him in the French Barbizon School. In our country there was Russell and all of those who painted the West. The one thing they all had in common was the different range of colors that limited their expression. They infused that same limitation of colors on their students so they all became schools of Rembrandt, schools of Caravaggio, schools of Titian, and so on.

It is as though you had never been given more descriptive words in the English language to describe different states of feeling. "That's sad." "That's happy." "That's pretty." "That's ugly." You would have to describe every feeling with those limited adjectives. You know more than that. Still, think of it that way. If more adjectives were available you would use those available to you—otherwise you wouldn't have stated anything. They did it with colors as well. So each of them selected their own pigments available to them by their color makers or the earth's that were around them. One of the most valuable pigments was Chinese vermilion. It was very highly priced and few painters used it. I saw some bills of Dürer and Holbein. If they used Chinese vermilion you paid extra for it. So it was with lapis lazuli—the blue. I read somewhere that a tube would cost around $1,800 in our type of money. It was used sparingly as a decorative asset. So that is why you don't see it and the vermilion. Obviously they used the earth colors instead.

The Egyptians had five or six colors. Just having the colors themselves wasn't enough, even at that time. The idea of creating the illusion of objects in space wasn't in existence at that

time. Value painting (tonal painting), the idea that values of the same color create the idea of recession, came very late in the consciousness of the human race. It wasn't known before the 15th century. The Greeks did not master the illusion of painting as much as they had their sculpture.

We know that unless you have oil paint you can't create the illusion. You can't do it with tempera because the oil paint gives you depth. There is no evidence that the Greeks had anything but the most primary of colors. It was kind of inconsistent. They pushed the knowledge of form to such wonderful ends. Why shouldn't they have done paintings as well? The reason they didn't is because they didn't have the materials, or the concept— smart as they were.

The art of painting reached perfection much later. In fact, it only reached perfection in the last one hundred years. Since Monet painted the *Grain Stacks,* let's say.

The range and different color schemes that each painter had in each nation or each section of a nation dealt with the surroundings and the pigments available to them. These were very limited. Within those limitations they created amazing things. I learned that no matter how wonderful these painters were, including Rubens and Rembrandt, Charles Webster Hawthorne's paintings had a more "modern look." Hawthorne used a modern palette. He didn't get the aerial feeling as well or as finely as Rembrandt with his palette, but Hawthorne's was a richer orchestration of color.

Now we know that there is only one way in which we see objects. Previous art forms, in which man expressed visual appearances, were so wonderful they convinced people they were the truth, the whole truth, and nothing but the truth. The fact is, they weren't. When you look at a Titian or a Rembrandt and have someone like me say, "If you gave me the gift to paint that way I would not want it." They are *passé.* They belong to the past age. They didn't have our vocabulary. If those men lived today they wouldn't paint that way any more than anyone with any sense would fly across the Atlantic with the plane Lindbergh used.

Every painter saw nature and expressed it according to the

convention he learned. Each was limited to his environment and his tutelage. They couldn't go further. They convinced themselves that that was how they saw nature, with the colors they painted.

Most of the paintings I am talking about were done indoors. Indoors it appears that you can get the illusion with a limited palette. The illusion of objects indoors appears more true to nature—the indoor color scheme. Indoors you don't have the exaggeration between the light and shade like you have in the sunlight, neither do you have the exaggeration of the color contrast. So you accept modeling in a more value sense, monochromatically almost, with just a little coloring as a reality. In the art form, where it is beautifully done, it is so convincing that unless you are alert to this you will believe that is how you see things. That's the way Rembrandt did it. It wasn't until the landscape painter came along and studied the problem, the creation of objects in light, that you discovered the dominant thing in a painting should be the light key of nature. This doesn't apply just to the landscape problem. Far from it. It applies to the portrait indoors. None of the old masters ever thought of it. The reason I thought of it was because I had the colors, painted outdoors, and learned it from outdoor painting.

Whatever object you paint in light or in shade, the color expresses the light planes in entirely different colors than those expressed in the shade. They are not the local color. The old outdoor painters could get away with it. If you look at Veronese, for example, what he did was to paint the local color. If an object was blue, he painted it blue by taking a lighter blue with some neutralization of it here and there, put some reflections into it to create the illusion of aerial perspective. Rembrandt did it especially well, but he did it more with earth colors. The further south you go in Europe you find painters, like Titian, who dealt with brighter colors and their canvases were more intense in color. The explanation for it is what Matisse and others said— the brilliance of the sunlight would make it impossible for Rembrandt to go there and paint further south in the soupy colors of the north. The brown soupy colors make the illusion of aerial perspective easier.

It takes longer to create the illusion of aerial perspective of objects in light and color than it does in a monochromatic system or in earth colors. You can take someone with no understanding of color and have him create an illusion of aerial perspective with yellow ochre, light red, black brown, umber and a touch of alizarin crimson or vermilion. You can create an aerial perspective almost immediately in charcoal, but if you take the new primary colors you're not going to get it. To take a red house and make it stay 100 yards away is something else, because the beginner has to over-color. The tonal painter didn't. He just had to get the difference between a raw umber tone or a darker or lighter one. That is simple. It is the way Rembrandt did it. The Venetians did it with bright colors, but they didn't get the atmosphere the Rembrandts have. They succeeded surprisingly well, but not as well as Rembrandt. When Velázquez did it in *Las Meninas* he practically used black, yellow ochre, and light red. Well, it is easier to make an atmosphere than that. It looks like the perfect illusion of reality if you don't know much about it. Rembrandt used warmer colors. Velázquez used more black to modulate things. His paintings have a "pearly" look. Cezanne brought up the fact that most colors in nature are subdued colors. Well, they are. Only a few things in nature are primary colors, like flowers.

So your development is to go from over-colored notes to the more neutral shades, which most of nature is seen in. That means that even bright objects in color have to be painted with subdued colors. On a sunny day, when you take the colors and put them side-by-side, they look like a bunch of muds, but when the muds are the right intensities they create the illusion of sunlight. These are muddier than a gray day. On a gray day you almost feel as though you can take the local color and directly express the gray day effect. The colors on a gray day are brighter. Most people think it is the opposite, that a sunny day should be painted with bright colors. You may start with them, but you will never get the illusion of distance and aerial perspective if you hold them in the raw state.

When you paint in the sunlight you have to learn the fact that what expresses the light is a different color than what expresses

the shade. This is obvious, but people don't understand it at first. Once you understand it and get it on a high level of perception, to your great surprise when you go indoors you will see it as well. I never saw an indoor painter, without instruction, go outdoors and understand what I am talking about and get the brilliance of outdoor light. They transfer the indoor light scheme to outdoors. It was the landscape painter who completely revolutionized the art of seeing and finally affected indoor painting, too. The background for the Old Masters was a landscape as a decorative asset.

We know now that there is only one way to paint. There is only one way to see objects in space and light. Even today there are people who are not conscious of it, which indicates the slowness of human perception. There is only one way you can see objects, by the masses of color in the light key. If it is sunny outside—then it should look sunny. Then it is purely a matter of the degree of your perception. There is only one way to do it—by putting the masses together that express that light scheme.

When it is a question of a sunny morning, then it is one light scheme. If it is a sunny afternoon, then it is another light scheme. If it is a gray day, another light scheme. If it is a hazy sunny day, still another light scheme. In every case it is done in the big masses of color holding to that light key. The single most important thing to always remember is *an object can never be seen out of the light scheme*.

The art of painting has now crossed all national boundaries. The past is like a blur of misconceptions; some truer than others. But now, for the first time, visual appearances and how we see them have come to the 20th century and the 20th-century mind should not be blinded by mannerisms and limitations of the past. Painting today, in its truest sense, is what people have tried to do with words in the past. They acknowledge an international Esperanto. Truly, it is an international language.

Hensche on Other Painters

Henry Hensche spared no painter from a profane or profound opinion. Mention the name of any painter and Henry could give retort in light of what he was teaching. In the previous text you encountered his analyses and comparisons. Some of these additional observations were made when I asked Henry to give quick reactions to some of the more prominent national and international artists.

<div align="center">§§§</div>

George Bellows—He said Henri never did teach him anything about color, and never will go down in history as a great painter of color, however, he was a great composer of American scenes.

Eugene Boudin—The one who brought Monet out of doors. His beachscapes were Monet's model for *en plein air* painting.

Paul Cezanne—He tried to add a more solid composition to the new color schemes of the Impressionists. He apparently felt the structure of form was lost in works like Monet's.

Jean-Baptiste Chardin—If you want to know anything about still life, look no further. There's never been another still life master since him.

Thomas Eakins—A tonal painter with the most studied knowledge of anatomy of any American painter.

Frederick Frieseke—He was the best of the American Impressionists, but he matured only at the very end. He was a value painter who caught on to Monet's ideas.

Paul Gauguin—More the poster man of the Impressionist period than anything else.

Childe Hassam—He was first a value painter and then used color as an adjunct to value. This was his early understanding (misunderstanding) of the Impressionist movement.

Robert Henri—He was a great teacher. His book reads with much inspiration. He was a value painter with interesting brushwork. Nothing more.

Hans Hoffman—I never really understood this "push-pull" business. Frankly, I don't think his students did either. I do know he was very inspiring to his students.

Johan Barthold Jongkind—He influenced Monet in his youth. Monet saw him painting out of doors and with broken color.

John Marin—Darling of the Modernists. His paintings look like a bomb was thrown in a place where they make wooden boxes or an exploding lumberyard.

Richard Miller—He painted women in an age when the female was revered in art. His color is decorative because he fell short of understanding Monet.

Claude Monet—All students should study his visual development. Forget the late paintings.

Pablo Picasso—He did more to confuse 20th-century art than anyone.

Pierre-Auguste Renoir—He could not remove black from his palette. Notice how he used it in the eyes of his figures and

even in his sunlight paintings. They are heavy with the use of black. It took the vitality out of his works.

Peter Paul Rubens—Objects seem to move in his paintings. He was the glory of the Baroque, but his treatment of color was no different from the Renaissance painters.

John Singer Sargent—He really didn't have to paint because he had money to do as he pleased. He didn't have to struggle to develop a better color sense except for his watercolors. He did those in quick moments of pleasure. They are overdrawn, but they are not overstudied. His color here comes from the immediacy of his painting.

Everett Shinn—Mainly an illustrator.

Abott Thayer—Hawthorne had much admiration for the way he glorified the female figure.

J.M.W. Turner—He clearly saw the light effects of nature, however, he lived immediately before the new pigments became available to give evidence of his vision.

John Twachtman—He was onto something great. He could have studied more in his color masses. He could have been the successor to Monet, but Hawthorne had to find the color painting system instead.

Vincent Van Gogh—He was the psychological expressionist of the Impressionist movement.

Diego Velázquez—In *Las Meninas* he painted no definable mass, but the suggestion of mass is present. He painted detail only to the degree that it would be seen from the viewer's distance from the painting. He could paint suggestively.

Leonardo da Vinci—He was impatient. He saw colors that he could not express. His vision was ahead of the trends of his

time, but he could not solve his visual problems because the chemistry of the new colors was not invented.

Andy Warhol—Non-sense. He sold to people with more money than sense. Pop art is non-sense.

Andrew Wyeth—Good draftsman, but no color sense. He painted the hicks and the sticks. His paintings were well received because all this barnyard stuff "smelled" good. He was admirable in a way because his work was a reaction against the Modernists, a kind of back-to-the-farm movement.

Afterword

When trying to sum up what I learned in my association with Hensche, I made a list. Although Henry taught me more than just the items on this list, these are the salient points for painting growth.

- See the light, not the object. The object *is* the light.
- Color is the universal adjective. It is only an adjective when it is descriptive. Art can be a noun when it is narrative. When it is a narrative, however, it loses its universality. Hensche is universal, therefore, a true "classical" painter.
- History is the constant redefinition of man, not just in art but in all things.
- Be a teacher of inquiry, not answers. Every great painting asks great questions. Failed paintings are too explicit.
- Painting is a record of a painter's visual development.
- The line is man's invention to represent nature. Color is nature's representation of itself.
- A painter is a teacher who helps others see the beauty of the world.
- We do not have to relearn all of art to get to the present-day knowledge of art, but a knowledge of the history of painting is essential to our visual development.

One of the most important things I learned was that the Hawthorne-Hensche approach to painting is not a "how-to-do" approach to painting. In compiling this book, I knew not to tackle a Hensche "technique." Other students of Hensche have

done this to various degrees of merit. Henry never really taught a "how-to" method. A detailed and lengthy procedure would only *seem* to be the solution to painting problems. Henry knew better than to do this to his students. *The answers rested in our own trained visual logic.* To this end, I remember my own words of gratitude to Henry before he died: "Thank you, Henry. Not for teaching me how to paint, or even how to see. Thank you for teaching me how to study."

His last long conversations with me were riddled with doubt, fear, and anger. He wanted Hawthorne's story to be told and seemed so frustrated with everyone's lack of understanding of what Hawthorne accomplished. In the end, the urgency in his demeanor was undeniable. I think it was the final cry of a man with a sense of history wanting his due. In addition to all he had done, Hensche wanted just a little more; not for self-aggrandizement, but for self-fulfillment. It was as though he was singing a strident and unresolved final chord in an elaborate, historical orchestration of color painting.

Will anyone care about the Monet-Hawthorne-Hensche legacy?

About the Author

JOHN W. ROBICHAUX holds a B.A. and M.Ed. from Nicholls State University. He is a teacher of history and Fine Arts Survey. He has studied with France Folse (1958–1965); John A. Meyer (1973–1974); Dorothy Billiu (1974–1980); and with Henry Hensche, both at Studio One, Gray, Louisiana and at the Cape School of Art, Provincetown, Massachusetts. Robichaux has mounted exhibitions of his works, taught painting and art history at Studio One, conducted workshops, directed art tours, and lectured on art and art history. His paintings are in private collections throughout the United States. In 1988 he assisted Mr. Hensche in publishing *The Art of Seeing and Painting*.